DREW DOG OUR DALMATIAN

BY BRUCE CONNOLLY

AuthorHouse™
1663 Liberty Drive
Bloomington, IN 47403
www.authorhouse.com
Phone: 833-262-8899

*Because of the dynamic nature of the Internet, any web addresses or links contained in this book may have changed
since publication and may no longer be valid. The views expressed in this work are solely those of the author and do not
necessarily reflect the views of the publisher, and the publisher hereby disclaims any responsibility for them.*

*Any people depicted in stock imagery provided by Getty Images are models,
and such images are being used for illustrative purposes only.
Certain stock imagery © Getty Images.*

This book is printed on acid-free paper.

ISBN: 978-1-6655-0978-7 (sc)
ISBN: 978-1-6655-0979-4 (e)

Print information available on the last page.

Published by AuthorHouse 12/01/2020

authorHOUSE®

BY **BRUCE CONNOLLY**

FOR YOUNG CHILDREN

AND CHILDREN LIKE

DREW DOG OUR DALMATIAN

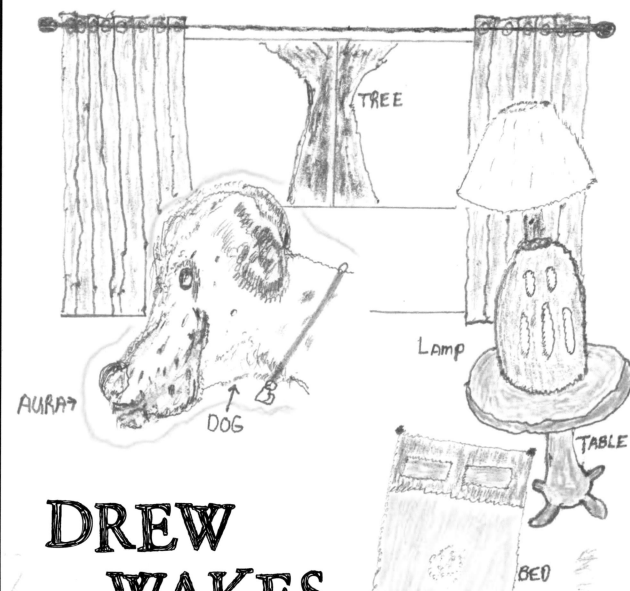

TREE

Lamp

AURA?

DOG

TABLE

BED

DREW WAKES UP SMILING

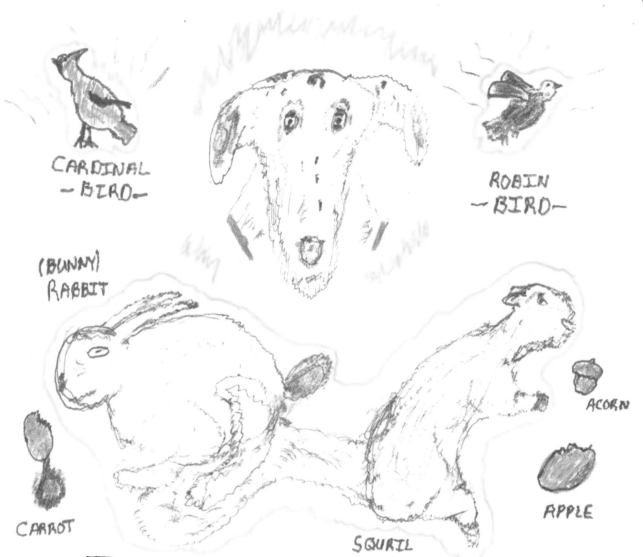

CARDINAL
~BIRD~

ROBIN
~BIRD~

(BUNNY)
RABBIT

ACORN

CARROT

SQURIL

APPLE

DREW
PLAYS
WITH
FRIENDS

DREW DRINKS AND EATS

Yum

Yum

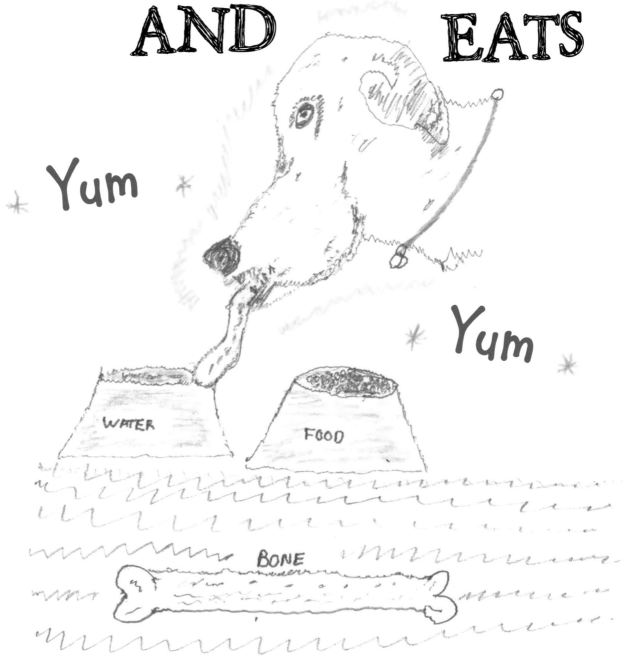

WATER

FOOD

BONE

DREW AND FAMILY

PLAY TIME

FUN FUN FUN

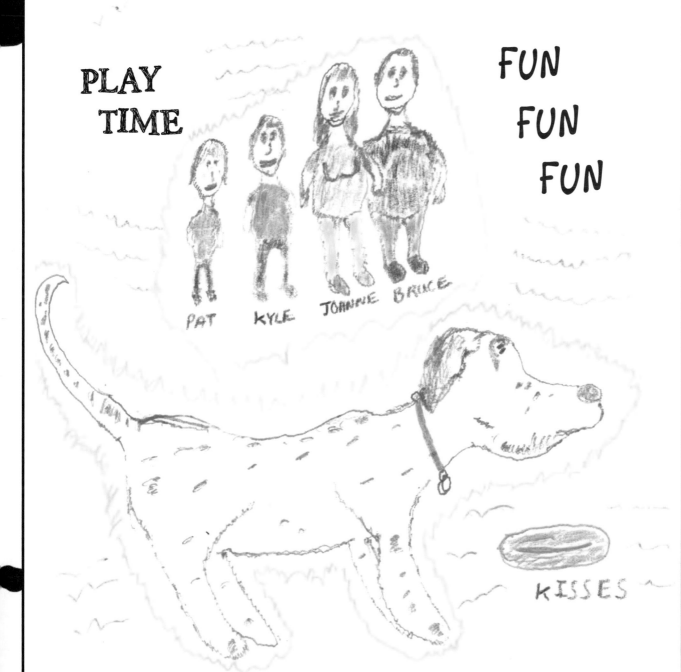

PAT KYLE JOANNE BRUCE

KISSES

DREW GOES FOR A WALK

LEASH

FOOT PRINTS

DAD CALLS
WHERE
IS MY
STEAK?!

PUZZLED

TABLE

LEASH

STEAK

A RIDE IN THE CAR

CLOUDS

SUN

CAR

DREW CAMPING

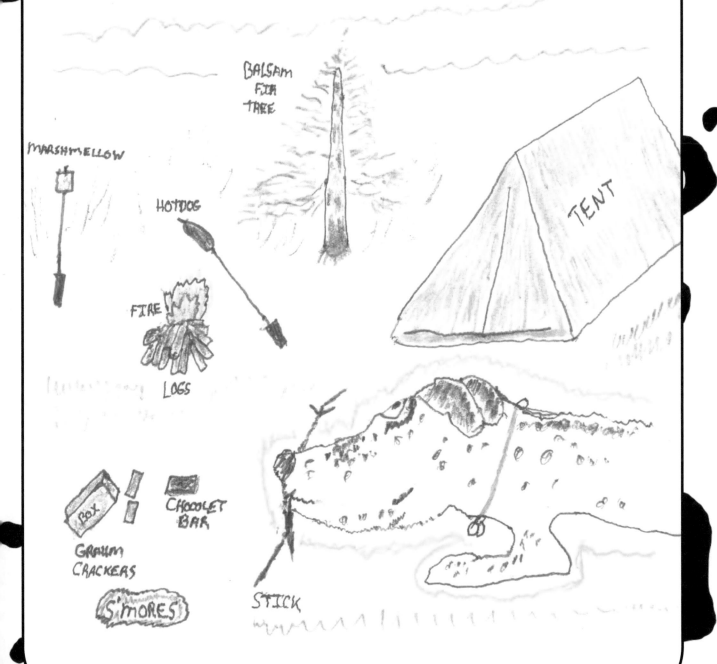

BALSAM
FIR
TREE

MARSHMELLOW

HOTDOG

TENT

FIRE

LOGS

BOX

CHOCOLET
BAR

GRAHM
CRACKERS

S'MORES

STICK

DAD AND DREW CANOEING AND FISHING

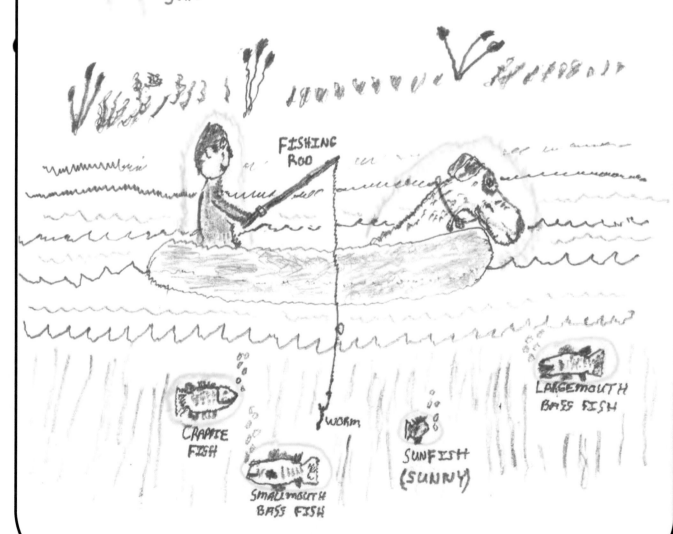

SUN

FISHING ROD

WORM

CRAPPIE FISH

SMALLMOUTH BASS FISH

SUNFISH (SUNNY)

LARGEMOUTH BASS FISH

DREW HOME HEAD CAUGHT IN MILK CARTON

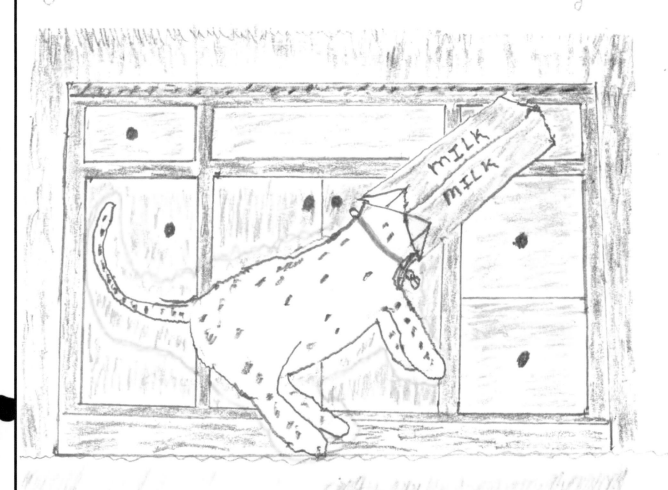

NIGHT TIME DREW

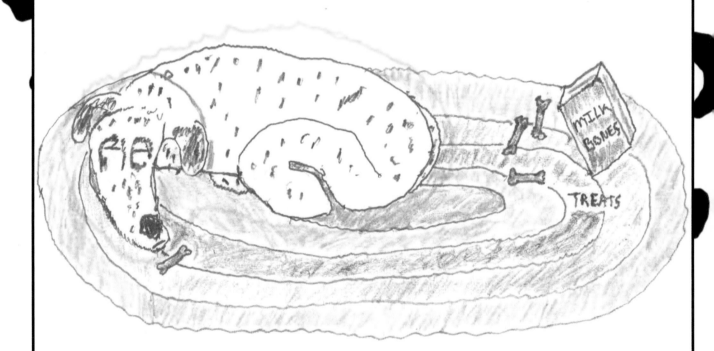

THE
END

SAYINGS

I LOOK TO THE STARS (UP)

I LOOK TO THE HEAVEN (UP HIGHER)

I LOOK TO GOD (UP HIGHEST)

I LOOK TO MY HEART (OUT)

I LOOK TO MY SOUL (OUT)

I LOOK TO MY SPIRIT (OUT)

I LOOK DOWN TO THE EARTH

I WISH THE BEST FOR THE GALAXIES

MY HEART IS LARGE
MY SOUL IS DEEP
MY SPIRIT IS WIDE

SIGNS

CROSS

HAMMER
OF
JUSTICE

I SEE THROUGH HEAVENS EYES

RED HAWK
WITH
GOLDEN WINGS

COLOR LEGEND

RED

GOLDEN YELLOW

YELLOW

TAN

LIGHT BROWN

BROWN

MAHOGAMY

RED ORANGE

PURPLE

GREEN

YELLOW GREEN

JADE GREEN

AQUA GREEN

GRAY

BLUE

SKY BLUE

LIGHT BLUE

PEACH

ORANGE

YELLOW ORANGE

MAGENTA

PINK

BLACK

WHITE

STAEDTLER COLORED PENCICIL - RED
CARYOLA COLORED PENCILS - OTHER COLORS

FINAL PAGE

Names:

TONGUE (DOG KISS)

Licks!

* * *

The
best of wishes
to
you!

* * *

*Your Friend
Bruce!*

About the Author

Bruce Connolly from Bloomington, Minnesota met his wife to be Jo Anne at a friends wedding. Jo Anne during our dating purchased Drew for ten dollars at a neighbors of hers puppy sale in South Minneapolis, Minnesota. After we were married we raised a family, Kyle (son), Patrick (son) and Drew (canine or dog) in Bloomington, Minnesota.

We had great adventures hiking and camping. We also had a cabin built on a 1.8-acre lot on the Flambaeu Flowage near the Village of Tony, in North Central Wisconsin. We all really enjoyed the woods the water and the people there.

Through the years I developed Parkinson's like tremors. This was due to medications I was on, however it was a dream of mine to write and illustrate this book about Drew and us.

You see, I am imperfect in a imperfect world.

Inspired by my family.

Written from my Heart, Soul and Spirit with Trembling Hands!

Printed in the United States
By Bookmasters